ELIZABETH CATLETT

IN THE IMAGE OF THE PEOPLE

Melanie Anne Herzog

The Art Institute of Chicago
Yale University Press, New Haven and London

Elizabeth Catlett: In the Image of the People has been published in conjunction with an exhibition organized by the Art Institute of Chicago and presented from November 13, 2005, to February 5, 2006.

First edition
Printed in the United States of America

Library of Congress Control Number:
2005934862

ISBN 0-300-11612-8

Published by
The Art Institute of Chicago
111 South Michigan Avenue
Chicago, Illinois 60603-6404
www.artic.edu

Distributed by
Yale University Press
New Haven and London
www.yalebooks.com

FRONT JACKET:
Sharecropper (detail), 1952, printed 1970; color linoleum cut on cream Japanese paper, 45 x 43.1 cm. The Art Institute of Chicago, restricted gift of Mr. and Mrs. Robert S. Hartman (1992.182).

FRONT COVER:
Sharecropper (detail), 1952, printed 1970; linoleum cut, 45 x 43.1 cm. Collection of Judy and Patrick Diamond.

BACK JACKET, FLAPS, AND BACK COVER:
"And a special fear for my loved ones" (details), from *The Negro Woman*, 1946-47; linoleum cut on cream wove paper, 21.3 x 15.3 cm. The Art Institute of Chicago, restricted gift of the Leadership Advisory Committee (2005.142.3).

ADDITIONAL PHOTOGRAPHY CREDIT:
p. 9, David Alfaro Siqueiros, *Dos niños*, 1956 © 2005 Artist Rights Society (ARS), New York/SOMAAP, Mexico City

Produced by the Publications Department of the Art Institute of Chicago, Susan F. Rossen, Executive Director

Edited by Robert V. Sharp, Associate Director of Publications

Production by Sarah E. Guernsey, Associate Director of Publications

Photography research by Sarah K. Hoadley, Photography Editor

Designed and typeset by Susanna Kim, Department of Graphic Design, and Photographic and Communication Services

Separations by Professional Graphics, Rockford, Illinois

Printing and binding by Original Smith Printing, Bloomington, Illinois

FOREWORD

Elizabeth Catlett was born in our nation's capital in 1915, the granddaughter of slaves. She graduated from Howard University, having studied design, drawing, printmaking, and art history. After a two-year stint teaching high school in North Carolina, she enrolled at the University of Iowa, where she was influenced by, among others, the regionalist landscape and figure painter Grant Wood.

It was at Iowa that Catlett began to make sculpture, and her *Mother and Child* of 1940 received first prize at the American Negro Exposition in Chicago, the same year in which she became the first student to earn an M.F.A. degree in sculpture from the University of Iowa.

In 1946 a Julius Rosenwald Fellowship enabled Catlett to travel to Mexico City, where she worked at the Taller de Gráfica Popular. There she began the series of prints that came to comprise *The Negro Woman*, a profound account of the conditions, both banal and heroic, in which the African American woman lived and worked. She has lived in both the United States and Mexico ever since.

Without question, Catlett is one of America's great artists of compassion, with a unique artistic, expressive vocabulary giving form to the dignity of the human condition, and especially that of the people with whom she most identifies: the African American and Mexican woman. Her powerful use of the carved line in prints and the carved form in sculpture lends an air of immediacy to her art. In both her prints and sculpture, one finds the representation of human dignity born of honest work in the face of arbitrary social constraints.

With this publication, we mark the legendary achievement of Elizabeth Catlett as an eloquent artist of expressive form as well as deep and sincere humane content. The Leadership Advisory Committee of the Art Institute, a group of leaders of Chicago's African American community, established the Legends and Legacy Award in 2005 and unanimously chose Elizabeth Catlett as its first recipient.

The Art Institute is proud to join the Leadership Advisory Committee in presenting this award, just as we express our appreciation to the Committee for making possible our acquisition of five prints by the artist. The Art Institute is dedicated to artists. It is for their art, and for the public on whose behalf we work, that we dedicate all of our human and material resources. Artists are a precious resource, and Elizabeth Catlett, as an accomplished artist and a human being of long life and consistent dedication to the struggles of people everywhere to live a dignified life, is without question worthy of our first Legends and Legacy Award.

We are deeply grateful to Elizabeth Catlett for accepting this award, and to the Leadership Advisory Committee— especially its chair, Denise B. Gardner, and Joan F. Small, chair of the Celebration Committee—for their guidance and support. We are equally grateful to Mark Pascale, Associate Curator of Prints and Drawings, and scholar Melanie Anne Herzog, author of this publication.

The Legends and Legacy Award is presented with all humility, knowing that to be a legend is to have lived a life, professionally and personally, to which we should all aspire, now and forever.

James Cuno

President and Eloise W. Martin Director
The Art Institute of Chicago

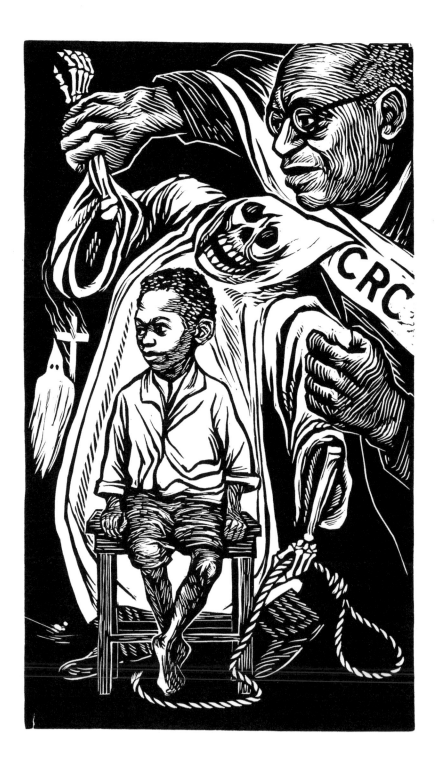

ELIZABETH CATLETT: IN THE IMAGE OF THE PEOPLE

Melanie Anne Herzog

Elizabeth Catlett's prints cry out in protest, proclaim solidarity, demand justice, and celebrate the determination, staunch resistance, and, at times against all odds, sheer survival of ordinary people. For more than sixty years, first in the United States and then in Mexico, Catlett has produced politically charged and aesthetically compelling graphic images of what matters most to her—the lives of everyday people, the heroines and heroes of African American and Latin American liberation movements. Printmaking for Catlett is a consciously political practice. At the same time, however, her prints—some intricately detailed and others elegantly spare—manifest her understanding that the power of an image resides in the artist's command of form, sensitivity to materials, and technical proficiency. As an artist for whom community is fundamentally important, Catlett is steadfastly convinced that her art must speak clearly to her audience, and the clarity and eloquence of the visual language she employs derive from her ongoing engagement with both artists and non-artists. Indeed, it is people that matter most to her.

EARLY YEARS: FORGING A VISION OF ART, POLITICS, AND COMMUNITY

Elizabeth Catlett was born in Washington, D.C., on April 15, 1915. Her father, a professor of mathematics at the Tuskegee Institute, died several months before her birth; to support their three children, Catlett's mother, also educated as a teacher, worked as a truant officer in Washington's public schools. The stories of slavery that her grandmother related and her mother's accounts of the anguish she witnessed in the slums of the nation's capital shaped Catlett's early awareness of the suffering and exploitation of black people in the United States, and laid the groundwork for Catlett's sense of identity as a black woman and her determination to give voice to black women through her art. Although few African American women at the time were practicing artists, and art museums in the segregated South were closed to African Americans, Catlett was determined to become an artist, an ambition strongly supported by her family.[1] She took her first steps toward that goal by enrolling at Howard University in Washington in 1931.

During the 1930s, Howard University was a center for lively debates about the role of the African American artist and modernist practice. Catlett worked with leading figures in African American art: she was introduced to the linocut process by James Lesesne Wells, and she studied art history with James Herring, design with Lois Mailou Jones, and painting and life drawing with James Porter. Catlett has credited Porter with demonstrating to her the discipline necessary to be an artist, and bringing to her attention the work of the Mexican muralists who played a key part in her decision first to visit and then move to Mexico in the following decade.[2] After her graduation, cum laude, from Howard with a bachelor of science degree in art in 1935, she taught for two years in the public schools in Durham, North Carolina, where she participated with lawyer (and later Supreme Court Justice) Thurgood Marshall in an unsuccessful

effort to gain equal pay for black teachers. Finding little time for her own art, however, Catlett decided to pursue graduate study at the University of Iowa, with the aim of teaching at the college level.

Catlett of course discovered that Iowa City was quite a different environment from the segregated black communities of Washington and Durham; she was one of only two African American students in the university's art department. She went to Iowa to study painting with Grant Wood, whose disciplined, methodical process of working and reworking an image has remained central to her own artistic practice, as has his exhortation that she take as her subject what she knows best. But sculpture became the focus of her graduate work, and in 1940 Catlett received the first master of fine arts degree earned in sculpture at the University of Iowa.

That fall Catlett began teaching at Dillard University in New Orleans, and found herself challenging Southern segregation in order to introduce her students to the world of art. While in Iowa, Catlett had gone with a group of students to see a large Picasso exhibition at the Art Institute of Chicago. When this show came to the Delgado Museum (now the New Orleans Museum of Art), she was determined that her students, the majority of whom had never been to an art museum, should see it. Though not itself closed to African Americans, the Delgado was nonetheless located in a city park where African Americans were not allowed; undaunted, Catlett had her students bused directly to the museum's door. Samella Lewis, one of these students and now a preeminent scholar of African American art, has written that "for the Dillard students Elizabeth Catlett was a commanding and fascinating individual. Although she looked like many of the traditional ladies of the South, her manner and actions were very different."[3]

Between her first and second year at Dillard, Catlett spent the summer of 1941 in Chicago, where she studied lithography at the South Side Community Art Center and ceramics at the Art Institute, and she resumed her work in sculpture. She lived with Margaret Burroughs (then Margaret Goss), one of the founders of the South Side Community Art Center, which was rapidly becoming the focus of artistic production and interaction for Chicago's thriving community of black writers, playwrights, and visual artists.[4] Among these artists was Charles White, who became Catlett's first husband. An overtly political stance distinguished this "Chicago Renaissance" from New York's Harlem Renaissance of the previous decade, for these young artists were radicalized by the economic devastation of the Great Depression and by the broadening reach of fascism in Europe.

Influenced to varying degrees by left-wing organizations, including the Communist Party, they formed coalitions and friendships across racial divides, just as through their art they challenged racial and class oppression which they recognized were often interlinked.[5] Catlett's introduction in Chicago to this dynamic and impassioned community of socially engaged artists galvanized her political consciousness and her recognition of the energizing power of art within a community.

In 1942 Catlett and White moved to New York. Catlett pursued lithography with Harry Sternberg at the Art Students League and sculpture with Ossip Zadkine, who had recently arrived as a refugee from the Nazi occupation of France. But the experience that had the strongest impact on Catlett during these years was her involvement with the George Washington Carver School, a community school for the working people of Harlem, where she taught sculpture and sewing and served as promotion director from 1944 until her departure for Mexico in 1946.[6]

Catlett's students at the Carver School opened her eyes to the realization that her own middle-class background had until that time foreclosed her understanding of the daily existence of working-class and poor African Americans. They also inspired her conviction that her art should be addressed to the ordinary people whom she describes as

"hungry for culture." In a 1981 address she spoke of "a lesson that began a change in my life's direction" at the Carver school:

About 350 of us were squeezed into a small room, sweating on a hot June night, with the windows and shades drawn [because of the World War II blackout]—most uncomfortable, listening to Shostakovich's *Seventh Symphony*. A professor from the Juilliard Music School had come to play this tape for our students, who were mostly from Harlem's poor people—janitors, day workers, laundresses, cooks, elevator operators, and so on—poor black people who served others.

When the first movement ended, the professor explained that since the second movement was very long we would take a break to refresh ourselves with some cold punch. Our students politely refused. They said, "No, the break can wait. We want to hear it all together." Now, ignorant me! I had thought they weren't interested in classical music.[7]

Not surprisingly, Catlett's involvement at the Carver School also left her with little time for her art. Therefore, when a Rosenwald Fellowship she had received in 1945 was renewed for a second year, she realized she would have to leave New York in order to complete her proposed project, a series of linoleum cuts, paintings, and sculpture depicting the oppression, struggles, and achievements of the black woman—a series directly inspired by her work at the Carver School. Catlett and White chose to go to Mexico because they were interested in its revolutionary murals and graphic art. Catlett also privately hoped that this sojourn might help their failing marriage.

Their interest in revolutionary Mexican art was shared by a number of African American artists, as well as artists of other ethnicities. The artists of the Harlem Renaissance were motivated by the Mexican muralists' visual articulation of

Fig. 1 Portrait of Elizabeth Catlett by Gloria Baker.

an indigenous *mexicanidad* that was fused with folk art, especially as they themselves looked to the "ancestral arts" of Africa and expressed pride in their African American heritage and identity.[8] During the 1930s and early 1940s the class consciousness of Mexican muralists and graphic artists resonated most strongly with the politics of the Chicago Renaissance artists and other socially engaged artists in the United States.[9] In addition to their social commitment, Catlett found inspiration in the Mexican artists' direct engagement with the experiences of ordinary people, their deliberately accessible style, and their centrality in the formation of a liberatory Mexican identity—all of which were important to her as she took as her subject the lives and experiences of African American women. She intended to spend a year in Mexico City studying sculpture at "La Esmeralda," the government-run art school, and working as a guest artist at the Taller de Gráfica Popular (People's Graphic Arts Workshop). Instead, after several months she returned to the United States to end her marriage, and then went back to Mexico in 1947 to establish permanent residence.

THE TALLER DE GRÁFICA POPULAR: PRINTS FOR PEOPLE'S SAKE

Catlett's decision to make her home in Mexico was in part a response to the U.S. government's increasingly vicious attacks on progressive artists, intellectuals, and activists following the end of World War II. In March 1947, for example, President Harry Truman issued Executive Order 9835, directing the Department of Justice to develop a list of "totalitarian, fascist, communist, or subversive" organizations. Among those named was the Carver School. That same year, the House Committee on Un-American Activities (HUAC) began holding hearings on the threat of Communist subversion within the United States. Individuals called as witnesses by the HUAC who refused either to give the names of their associates or to answer the Committee's questions were cited for contempt; many lost their jobs, suffered continued persecution, and received prison sentences.[10] In this environment of political intimidation, Catlett soon realized that, had she continued to reside in her country of origin, suspicion of her apparent political sympathies would have inevitably resulted in government harassment and questioning by HUAC. Fortunately, she had found respite in Mexico from the incessant racism she faced in the United States, and she discovered a community of artists at the Taller de Gráfica Popular whose aims were in accord with her own.

Founded in 1937 by graphic artists and muralists Leopoldo Méndez, Raúl Anguiano, Luis Arenal, and Pablo O'Higgins, the Taller de Gráfica Popular was a workshop dedicated to the Mexican people; at its center was a much-loved printing press inscribed "Paris 1871" that was popularly believed to have been used by the graphic artists of the Paris Commune. Employing straightforward and expressive realism and immediately recognizable imagery, workshop members worked collectively and individually to create print portfolios, posters, and broadsides that celebrated the history of the Mexican people. They also created materials that supported unions and agricultural workers; endorsed national literacy programs and movements for social justice; and condemned fascism.[11] Leopoldo Méndez's 1942 linocut *Deportación a la muerte (Transport to Death)* illustrates the TGP's grasp of linoleum as an expressive graphic medium. Published in 1943 in *El Libro Negro del Terror Nazi en Europa (The Black Book of Nazi Terror in Europe)*, an international collaboration illustrated with drawings and prints by TGP members and other artists from the United States and Europe, *Transport to Death* (fig. 2) illuminates the awareness among international antifascists of the extent of Nazi atrocities that were yet to be acknowledged by the United States government.[12]

Though the tremendous paintings of the revolutionary Mexican muralists of this period, particularly *los tres grandes* Diego Rivera, José Clemente Orozco, and David Alfaro Siqueiros, were better known, the graphic images of the Taller de Gráfica Popular—pasted on walls and signboards throughout Mexico City—were perhaps more effective as immediate political commentary on urgent topical issues. Rivera, Orozco, and Siqueiros all supported the workshop's efforts during the 1940s, though

Fig. 2 Leopoldo Méndez (Mexican, 1902–1969), *Deportación a la muerte (Transport to Death)*, 1942; linoleum cut on tan wove paper, 35.2 x 51.1 cm. The Art Institute of Chicago, William McCallin McKee Memorial Collection (1943.1362).

Siqueiros disagreed with the TGP's assertion that revolutionary art should be realistic in form as well as content in order to speak most directly to the needs of the people. He argued instead that revolutionary art should incorporate new media, new styles, and technology appropriate to a revolutionary age.[13] Still, he did utilize the services of the workshop's lithography technician to produce limited editions of "traditional" prints such as *Dos niños* of 1956 (fig. 3).

By the time Catlett arrived in Mexico in 1946, members of the Taller de Gráfica Popular had produced thousands of linoleum cuts, woodcuts, and lithographs that were generally printed on cheap, newsprint-quality paper, sometimes in unnumbered editions. Foremost among the projects underway when she arrived was *Estampas de la Revolución Mexicana*, a portfolio of eighty-five linocuts with narrative titles and explanatory text that celebrates the revolutionary fervor, courageous acts, and tragic martyrdom of common people as heroes of the Mexican Revolution.[14] Many of the portfolio's images—some with bold, angular contour lines and dramatic light and dark contrasts, others intricately incised, detailed renderings of figures and their surroundings—were taken from well-known photographic images of the Mexican Revolution that would have been immediately recognizable to their largely illiterate audience of Mexican working people. This portfolio

served as a model for Catlett as she envisioned *The Negro Woman*, her own epic historical narrative of black women's experiences in the United States.

Undertaken in 1946 and 1947, *The Negro Woman* is a series of fifteen linoleum cuts that acknowledges the harsh reality of black women's labor, honors several renowned heroines in particular, and renders visible the fears, struggles, and achievements of ordinary African American women. At once graphically monumental and intimately scaled, these prints draw the viewer in close. Face to face with these striking images, we are summoned as well by the accompanying narrative to join in Catlett's identification with her subject, embodied in the first-person naming of each image:

I am the Negro woman. I have always worked hard in America In the fields In other folks' homes I have given the world my songs. In Sojourner Truth I fought for the rights of women as well as Negroes. In Harriet Tubman I helped hundreds to freedom. In Phillis Wheatley I proved intellectual equality in the midst of slavery. My role has been important in the struggle to organize the unorganized. I have studied in ever increasing numbers. My reward has been bars between me and the rest of the land. I have special reservations Special houses And a special fear for my loved ones. My right is a future of equality with other Americans.[15] (See plates 2–16.)

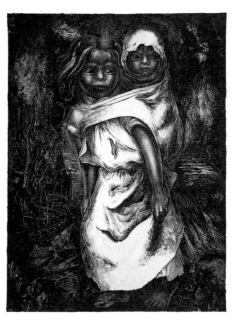

Fig. 3 David Alfaro Siqueiros (Mexican, 1896–1974), *Dos niños*, 1956; lithograph, 77.3 x 58.5 cm. The Art Institute of Chicago, promised gift of Dorothy Braude Edinburg to the Harry B. and Bessie K. Braude Collection (5.1996).

As art historian Richard J. Powell has noted, "Catlett invites everyone— women, men, blacks, whites, whomever— to act as surrogate 'Negro women,' if only via the stating of each title."[16] Spoken aloud or read silently, the repeated "I" of this narrative demands witness through the act of identifying.

Though they vary somewhat in their style, as would be expected of work in a medium relatively new to a young artist, most of the prints in Catlett's *Negro Woman* series are forcefully gouged with sharp, angular strokes that manifest her strong sense of design and her attentiveness to the textural possibilities of

linoleum cuts. Composition reinforces meaning: the vast spatial recession of "In the fields" (plate 4), for example, signifies the sharecropper's unending labor, while the domestic worker in the tightly framed "In other folks' homes" (plate 5) has no room to move, her out-sized muscular arms and hands unable to break free of the restraining edge of the image and the constraints of her circumstances. The historical figures Catlett depicted are based on iconic and frequently reproduced engravings: Sojourner Truth, whose celebrated "Ain't I a Woman" speech at an 1851 women's rights convention offered an eloquent analysis of race, gender, and black women's experience; Harriet Tubman, who in the 1850s guided hundreds of slaves to freedom and inspired countless others; and Phillis Wheatley, the enslaved, eighteenth-century poet who wrote of freedom (see plates 7–9).

Images that represent the steadfast activism and endurance of ordinary African American women recall those who inspired Catlett's *Negro Woman* series and her earlier life experiences. "I have studied in ever increasing numbers" (plate 11) invokes her students at the Carver School, while "I have special reservations" (plate 13) bitterly recalls the delimiting segregation of the American South and, more particularly, her advocacy in support of Dillard students who were wrongfully jailed for allegedly removing the "Colored Only"

signs from a New Orleans city bus.[17] But the North does not avoid reproach: "Special houses" (plate 14) depicts the overcrowded living conditions faced by African Americans in New York, Chicago, and other Northern cities, as the two exhausted-looking women are pressed forward to the surface of the image by the tenements that fill the space behind them. The presence of women is also implied in "And a special fear for my loved ones" (plate 15), which focuses on the prostrate form of a lynched man. Three pairs of feet above him could be those of his attackers or of others still hanging from ropes like the one encircling the dead man's neck. Both past and present fears are invoked here. In contrast, the final image of the series looks to "a future of equality with other Americans" (plate 16).

With *The Negro Woman*, Catlett claimed for black women's lives the historical importance accorded the Mexican Revolution in the TGP's *Estampas de la Revolución Mexicana*. This series was indebted as well to the examples of her African American contemporaries, especially her friend Jacob Lawrence's series of paintings of historical heroes and events, most notably his *Migration of the Negro* series of 1940–41. Catlett was also inspired by German printmaker Käthe Kollwitz's powerfully expressionistic images of women, their large, strong hands connoting their working-class

status. Most particularly, though, she found a model for her own development as a printmaker in the stylistic approach of artists such as Leopoldo Méndez, whose facility at exploiting to their fullest the textural and tonal possibilities of linocuts and whose ability to render the workshop's political messages in aesthetically compelling graphic terms made him a leader among the workshop's collective membership (see fig. 4).

Catlett brought to Mexico a strong sense of identity as a black woman, forged during her early years in the United States and informed by her historical awareness and her politics, and an unwavering commitment to speak through her art to the ordinary people she saw as hungry for culture— to produce art for people's sake. In Mexico, she reframed and expanded her sense of identity to encompass her identification with the struggles and aspirations of the Mexican people. Layered with the accretions of her social, political, and artistic affiliations and experiences, identity for Catlett can be thought of as an active process of iden-tification; as cultural sociologist Stuart Hall asserts, identity is "not an essence but a *positioning*."[18] Furthermore, Hall has stressed that "identity is always in part a narrative, always in part a kind of representation Identity is not something which is formed outside and then we tell stories about it. It is that which is narrated in one's own self."[19]

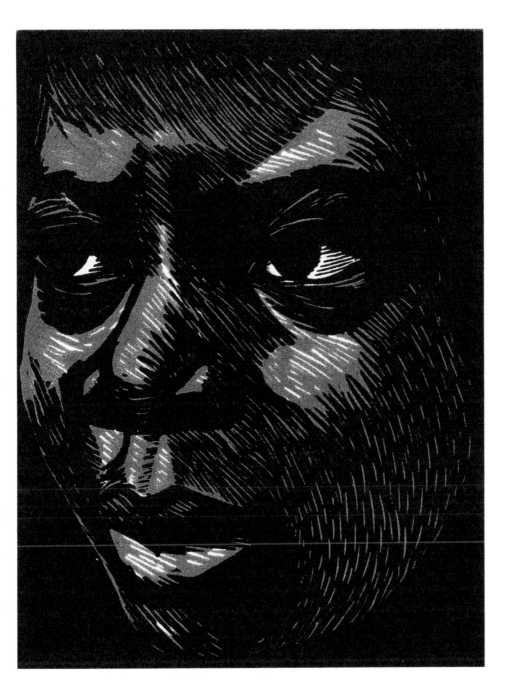

PLATE 2

"I am the Negro Woman"

from *The Negro Woman*, 1946-47;
color linoleum cut, 13.3 x 10.1 cm.
Collection of Elizabeth Catlett.

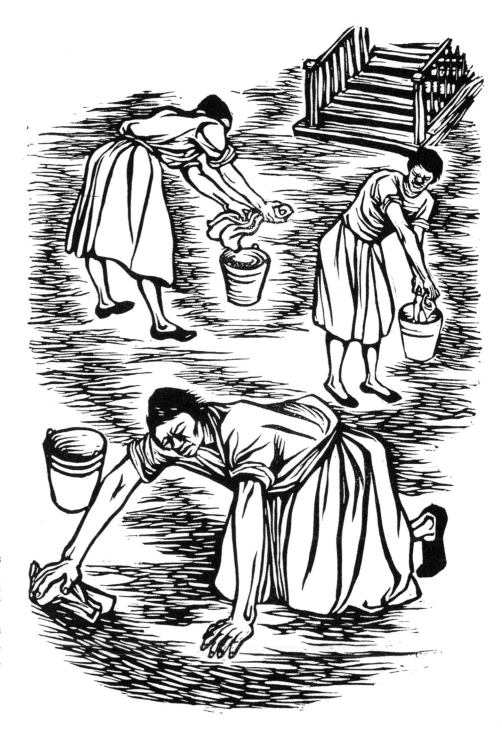

PLATE 3

"I have always worked hard
in America"

from *The Negro Woman*, 1946-47;
linoleum cut, 21.5 x 15 cm.
Collection of Elizabeth Catlett.

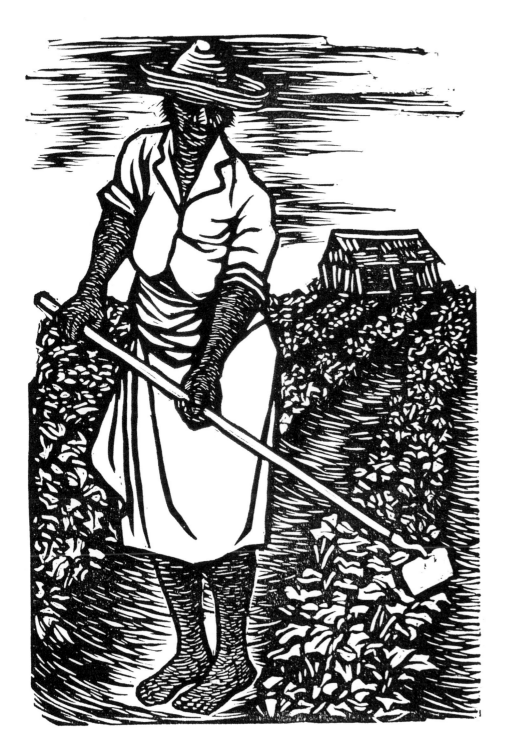

PLATE 4

"In the fields"

from *The Negro Woman*, 1946-47;
linoleum cut, 22.5 x 15 cm.
Collection of Elizabeth Catlett.

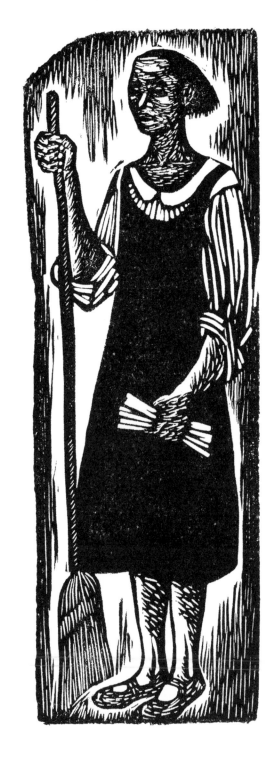

PLATE 5

"In other folks' homes"

from *The Negro Woman*, 1946-47;
linoleum cut on cream wove paper, 16.2 x 5.5 cm.
The Art Institute of Chicago, restricted gift of the
Leadership Advisory Committee (2005.142.1).

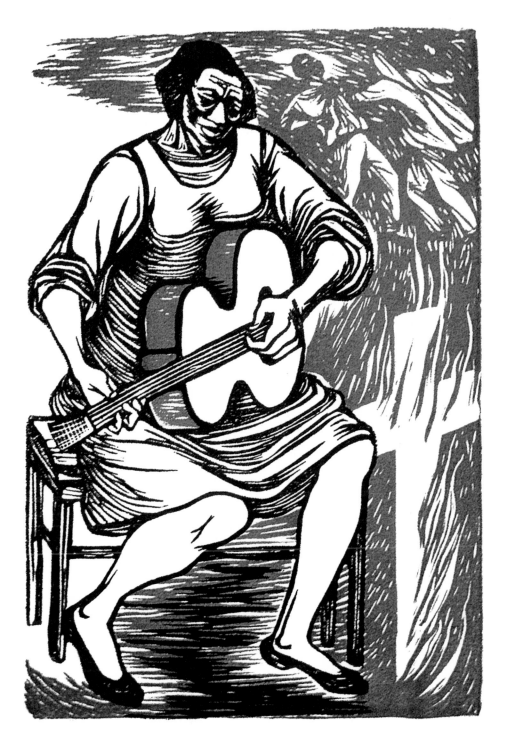

PLATE 6

"I have given the world my songs"

from *The Negro Woman*, 1946-47;
color linoleum cut, 18.8 x 12.7 cm.
Collection of Elizabeth Catlett.

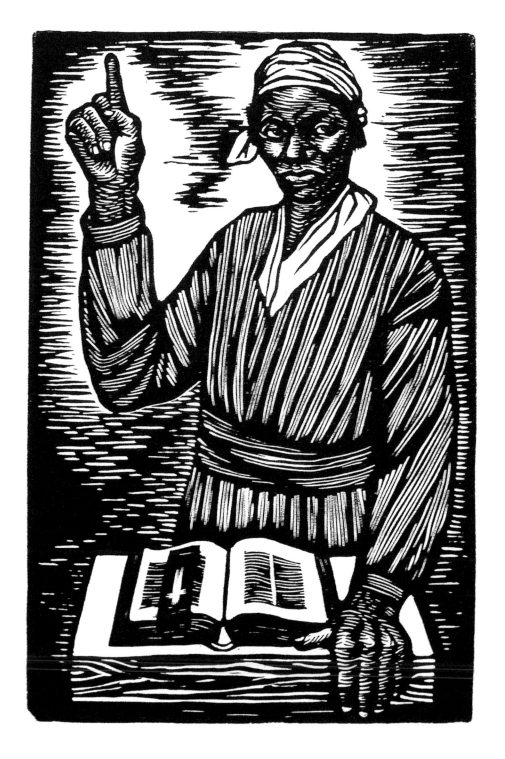

"In Sojourner Truth I fought for
the rights of women as well
as Negroes"

from *The Negro Woman*, 1946–47;
linoleum cut, 22.5 x 15 cm.
Collection of Elizabeth Catlett.

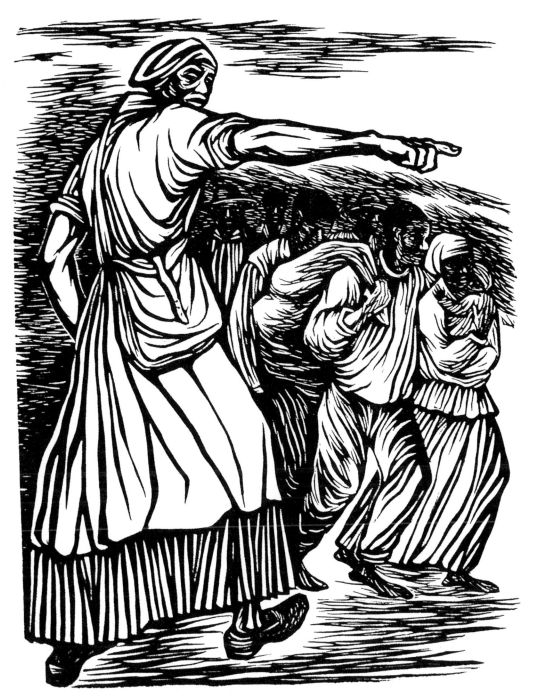

PLATE 8

"In Harriet Tubman I helped
hundreds to freedom"

from *The Negro Woman*, 1946-47;
linoleum cut, 23 x 17.5 cm.
Collection of Elizabeth Catlett.

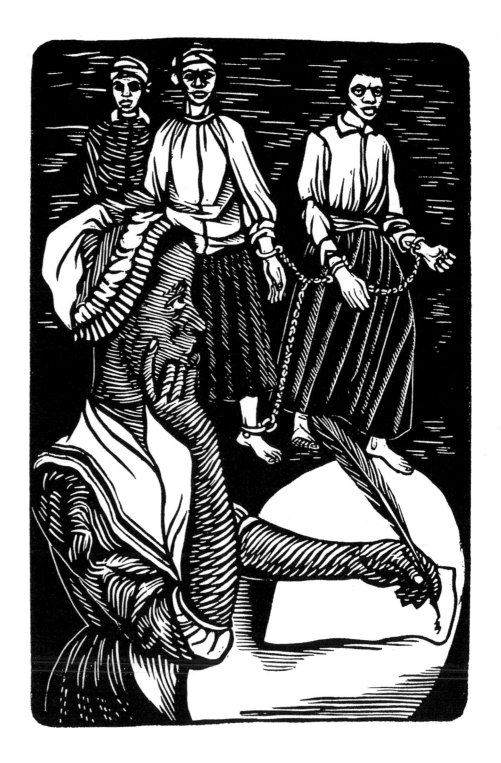

PLATE 9

"In Phillis Wheatley I proved
intellectual equality in the
midst of slavery"

from *The Negro Woman*, 1946–47;
linoleum cut, 23 x 14.7 cm.
Collection of Elizabeth Catlett.

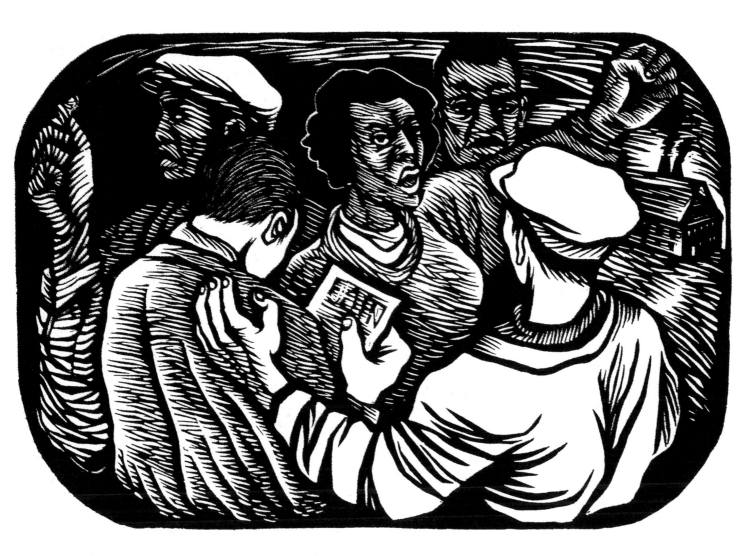

PLATE 10

"My role has been important in the struggle to organize the unorganized"

from *The Negro Woman*, 1946-47;
linoleum cut, 14.6 x 22.9 cm.
Collection of Elizabeth Catlett.

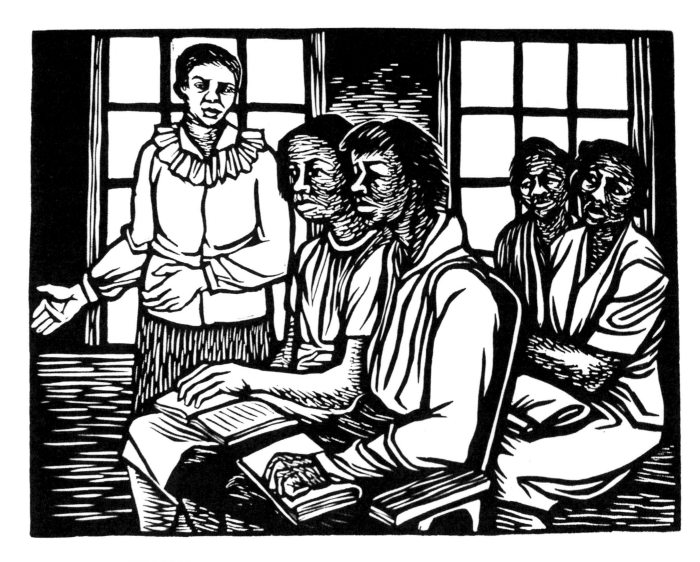

PLATE 12

"My reward has been bars between
me and the rest of the land"

from *The Negro Woman*, 1946-47;
linoleum cut, 15 x 11.5 cm.
Collection of Elizabeth Catlett.

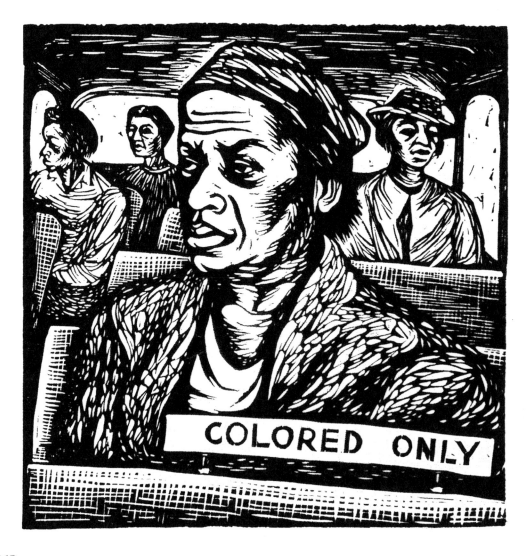

PLATE 13

"I have special reservations"

from *The Negro Woman*, 1946-47;
linoleum cut, 15.5 x 15.5 cm.
Collection of Elizabeth Catlett.

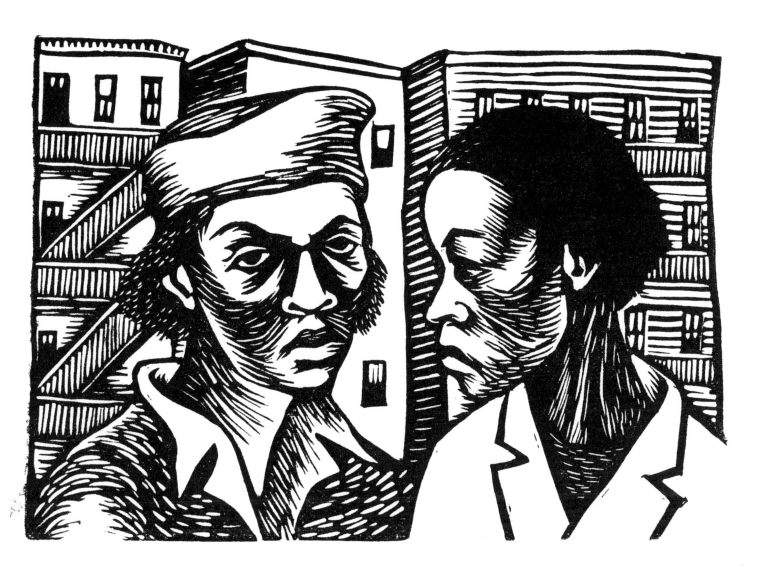

PLATE 14

"Special houses"

from *The Negro Woman*, 1946-47;
linoleum cut on cream wove paper, 10.8 x 15 cm.
The Art Institute of Chicago, restricted gift of the
Leadership Advisory Committee (2005.142.2).

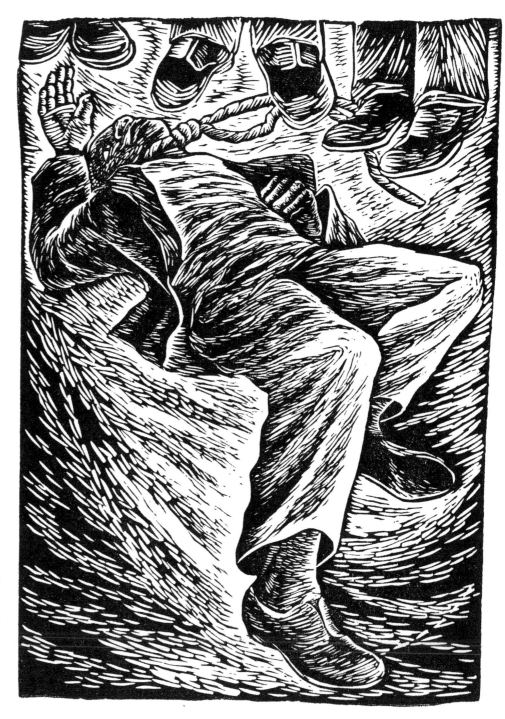

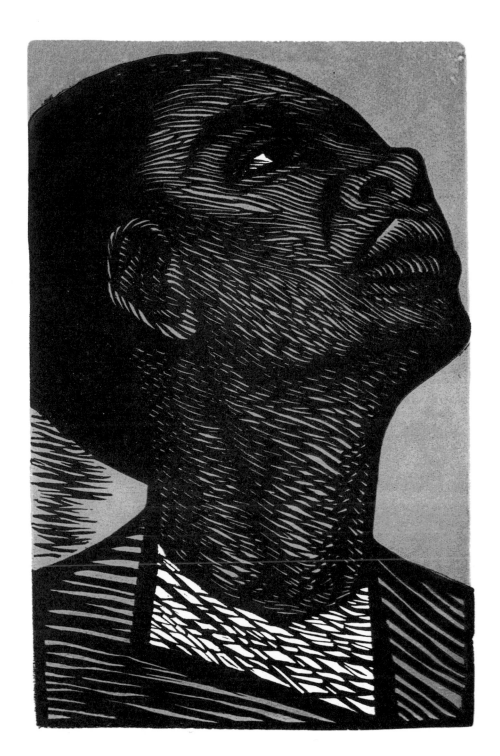

PLATE 16

"My right is a future of equality with other Americans"

from *The Negro Woman*, 1946-47;
color linoleum cut, 22.9 x 15.6 cm.
Collection of Elizabeth Catlett.

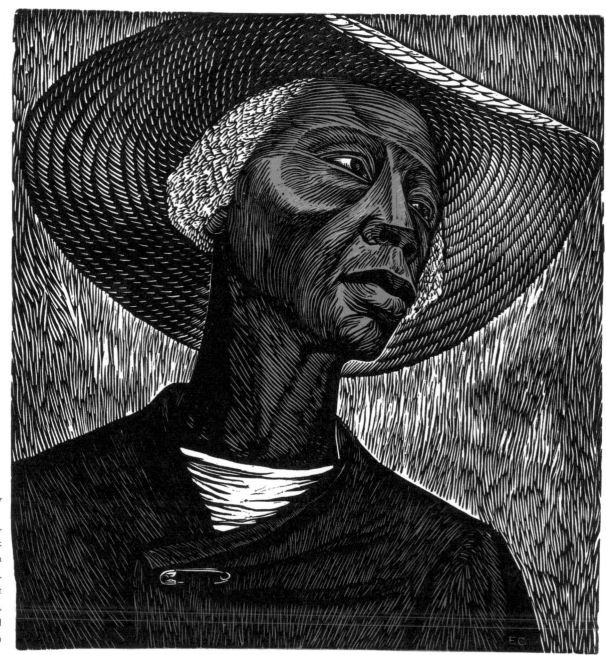

PLATE 17

Sharecropper, 1952,
printed 1970;
color linoleum cut on cream
Japanese paper,
45 x 43.1 cm. The Art
Institute of Chicago,
restricted gift of Mr. and
Mrs. Robert S. Hartman
(1992.182).

Recalling the "I am" of her *Negro Woman* series, identification—the act of identifying—became a fundamental and politically charged aspect of Catlett's printmaking. And it is the basis for Catlett's renaming this series *The Black Woman*, in accord with the designation now favored by African Americans, when she resumed exhibiting in the United States in 1971. When shown in Mexico in the intervening decades, the series was titled *La mujer negra*; the Spanish *negra*, which translates as "black" as well as "Negro" in feminine form, did not demand the renaming that was politically necessary in English.

When she decided to make her home in Mexico, Catlett immersed herself in Mexican life and culture and in the activities of the Taller de Gráfica Popular. Her initial "guest" status at the workshop was eventually exchanged for full membership, and she embraced the collective process of the TGP, depicting subjects consistent with those of other workshop members and taking its audience, which encompassed ordinary Mexican people as well as people working for social justice in other parts of the world, as her own. In 1947 she married fellow printmaker Francisco Mora (1922–2002); she and Mora remained members of the TGP until 1966. While she was raising their three sons— Francisco, born in 1947; Juan, born in 1949; and David, born in 1951— the Taller served as her primary community.

Only when her youngest son went to kindergarten was she able to resume her work in sculpture; and in 1959 she became the first woman sculpture professor at Mexico's National Autonomous University, where she taught until 1975.

At the TGP Catlett made prints in the evenings and always tried to attend the Friday night collective meetings to which members of other organizations often came with requests for graphic images in support of their work. Central to these meetings were critiques of works-in-progress, intended to aid workshop members in producing prints that most effectively conveyed their desired message. Catlett's description of these lively sessions captures the sense of community and camaraderie that was fundamental to the workshop's success:

The criticism in the Taller was always positive, like somebody would say, "I think that you have a very good design, and it's very clear, but why did you hide the hands?" And so they would say, "I can't draw hands." "Well, I'll help you, or I'll draw the hands." Or they would say, "This symbolism has been used over and over, it's time we had something new," and so then they would have a general discussion of what you could use And it didn't matter how many people worked on something, as long as it came out the best we could make it.[20]

Increasingly identifying with the people to whom the Taller de Gráfica Popular was dedicated, Catlett also adopted the workshop's visual language. By the early 1950s, the vigorous angularity of her early prints had given way to a rounder, more intricately textured handling of linocuts and lithographs. Deftly cut into linoleum and drawn with grease crayon on lithography stones, her figures are modeled with the subtle range of tonality seen in the work of the TGP's most technically accomplished printmakers.

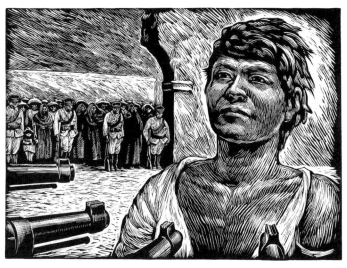

Fig. 4 Leopoldo Méndez, *Fusilamiento (Firing Squad)*, 1950; woodcut, 30.4 x 42 cm. The Art Institute of Chicago, promised gift of Dorothy Braude Edinburg to the Harry B. and Bessie K. Braude Collection (38.2002).

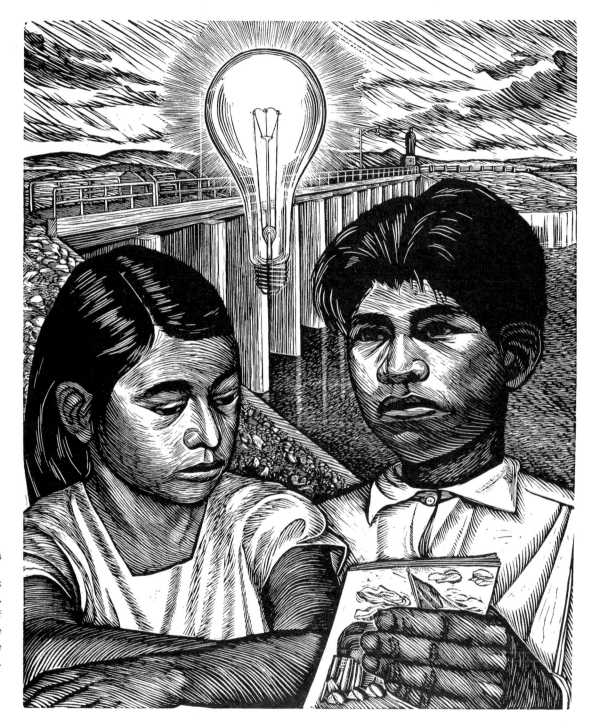

PLATE 18

La presa (The Dam), 1952;
linoleum cut on gray laid paper,
45 x 37 cm. The Art Institute of
Chicago, restricted gift of the
Leadership Advisory Committee
(2005.144).

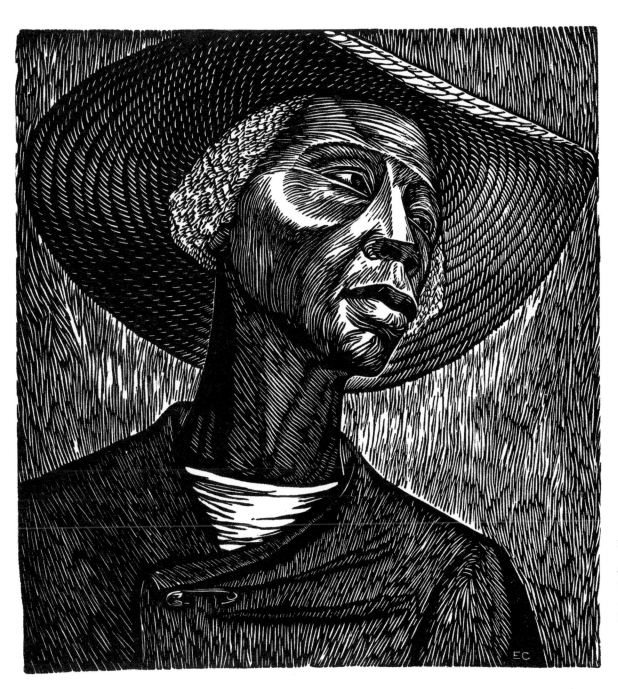

PLATE 19

Sharecropper, 1952,
printed 1970; linoleum cut,
45 x 43 1 cm. Collection of
Judy and Patrick Diamond.

Her embrace of the workshop's graphic style was emblematic of her growing understanding of the meaning of *mestizaje*, the blending of indigenous, Spanish, and African ancestries shared by many in Mexico, and of her recognition of commonalities and convergences among African American and Mexican peoples' histories and experiences. She was also determined that her graphic images of Mexicans—working women, urban laborers and *campesinos*, children working and caring for smaller children, homeless children in the city, indigenous children in the country—and African Americans—mothers, workers, ordinary people, and historical heroines—speak clearly to her various audiences, African American and Mexican. Again, Richard J. Powell has written of her prints: "When one is face to face with Elizabeth Catlett's graphic work, after celebrating her technical accomplishments and eye for eloquence, one must acknowledge, then marvel at, the inclusive, international dimensions of her subjects' blackness, femaleness, and *mejicanismo*."[21]

Mexico became the vantage point from which Catlett articulated her African American identity in prints such as *Civil Rights Congress* of 1950, which invokes the documentary specificity and graphic symbolism employed by the TGP. *Civil Rights Congress* (plate 1) commemorates this organization's presentation in 1950 of a petition to the United Nations charging the United States with genocide against African Americans. Immediately recognizable is William Patterson, organizer for the Communist Party and national executive secretary of the Civil Rights Congress, who restrains the figure menacing the seated child. This robed figure, his shoes and trousers visible beneath his garment, is unmistakably a member of the Ku Klux Klan. At the same time, however, his face and arms are those of a *calavera*, or skeleton figure, an image readily legible to a Mexican audience familiar with this symbol used in popular prints since the time of José Guadalupe Posada, the progenitor of Mexico's graphic tradition of incisive social commentary. In addition, Catlett's lighting of the face of the child, clearly of African descent, recalls her earlier treatment of African American physiognomy inspired by West African masks. Thus, with its meaning clear to both her African American and Mexican audiences, this print speaks symbolically and stylistically across cultural boundaries.

Most consistent with the work of other TGP artists are the prints Catlett made for the workshop's various collective projects. *La presa* (*The Dam*) of 1952 (plate 18) celebrates the harnessing of the hydraulic resources that bring electricity to the rural areas of Mexico, here symbolically illuminating the education of Mexico's people. The meticulously rendered details of the bridge, water, and distant landscape, along with the straightforward realism of the two youths engaged in study of what appears to be a TGP-illustrated text, clearly convey the meaning of this relatively large linocut, made for a government-sponsored conference and exhibition on hydraulic resources.[22]

Sharecropper (plate 19), also produced during the early 1950s, is one of Catlett's most celebrated linocuts. Although the image was initially printed in black and white, some early proofs also include experiments with color. One of these, titled *Negro Woman*, won the second-place award for prints in 1952 at the Atlanta University Art Annual, at that time the most important venue for African American artists.[23] While the subject recalls the Southern women of Catlett's earlier *Negro Woman* series, her carving of the linoleum block for *Sharecropper*—its subtly varied, closely spaced hatchings delineating contour, pattern, material, and texture— reflects the fluency she developed in this medium at the TGP. At the same time, the expressionistic angularity of the woman's careworn face marks *Sharecropper* as kin to many of Catlett's depictions of African American women workers. Characteristic of Catlett's portrayal throughout her career of strong, dignified black women, *Sharecropper*'s authoritative compositional focus and carefully delineated forms are emblematic of the attention and respect Catlett feels her subject deserves.

In the climate of the Cold War, the politics and social realist style of the Taller de Gráfica Popular were regarded as dangerous; the TGP was ultimately labeled a "Communist Front organization" by the U.S. Attorney General, and its members were prohibited from entering the United States.[24] Catlett's affiliation with the workshop thus reinforced the scrutiny of her activities in Mexico, and she was subjected to harassment by the United States embassy throughout the 1950s. When the Mexican government's increasing complicity in the deportation of U.S. citizens wanted for questioning by HUAC meant that she was no longer safe in her adopted country, Catlett applied for Mexican citizenship; she received it in 1962 and was immediately declared an "undesirable alien" by the U.S. State Department and denied entry to the United States. Her 1961 visit to the United States to deliver the keynote address to the Third Annual Meeting of the National Conference of Negro Artists in Washington was therefore her last until she was granted a visa to attend the opening of her solo exhibition at the Studio Museum in Harlem in 1971.[25]

NEGRO ES BELLO: TRANSNATIONAL SOLIDARITY

During the 1960s the political climate in the United States shifted again as the Civil Rights Movement, the protests against the Vietnam War, the Black Power Movement, and other activities brought the politics of solidarity and liberation to the streets. Though prohibited from traveling to her country of origin, Catlett, from her vantage point in Mexico, turned her attention to the Civil Rights and Black Power struggles raging in the United States, focusing her art with passion and clarity on the aspirations and struggles of her sisters and brothers, responding with fury against the police brutality directed at African Americans, and demanding witness for women's roles in movements for black liberation.[26] The Black Arts Movement, a loosely connected, community-based network of artists devoted to the development of a collective

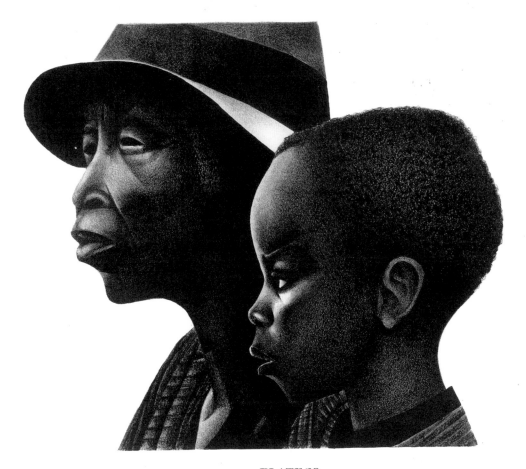

PLATE 20

These Two Generations, 1987;
lithograph, 56 x 76.2 cm. Collection of Isobel Neal.

aesthetic of self-determination rooted in black nationalism, became the community that sustained her from afar.

Informed by her transnational perspective, her prints from this period, now including serigraphs and monoprints, manifest the affinity Catlett felt for the Black Arts Movement's visual expression of black identity, pride in African ancestry, and the revolutionary promise of Black Power. Her earlier *Sharecropper*, reprinted beginning in 1968 using the original linoleum block, emphasizes the woman's ethnicity through the addition of color (see plate 17). Monumental, seen from below, this imposing image of a rural Southern fieldworker became an iconic image of black pride.

In her prints Catlett has continued to emphasize across national borders her commitment to making visible the experiences of African American women and children, and to social justice for African Americans and other oppressed peoples. Though her work became less confrontational in the decades following the ferment of the 1960s and early 1970s, she proclaimed solidarity with antifascist and anticolonial struggles in Chile and Central America during the 1980s in linocuts that recall the TGP's most politically outspoken work. Of her enduring commitment to her chosen subjects she said in 1983:

Because I am a woman and know how a woman feels in body and mind, I sculpt, draw, and print women, generally black women. Many of my sculptures and prints deal with maternity because I am a mother and a grandmother. Once in while I do men because I love my husband and sons, I share their sorrows and joys and I fear for them in the unsettled world of today.[27]

Although she and Francisco Mora left the TGP in 1966, in linocuts, lithographs, serigraphs, and monoprints Catlett has continued to draw upon the consummate mastery of graphic techniques she developed at the Taller de Gráfica Popular. Her 1987 lithograph *These Two Generations* (plate 20) exemplifies her handling of lithographic crayon drawing in its full range of tonalities and subtle textures. An image of intergenerational continuity, *These Two Generations* restates the dignity and resilience of *Sharecropper* as the sensitively rendered profile of an elderly worker is paired with that of a young child.

Catlett's *Survivor* of 1983 (plate 21) also depicts a rural Southern U.S. laborer, careworn and strong. Derived directly from Dorothea Lange's *Ex-slave with a Long Memory*, a photograph Lange made in Alabama in 1937-38 while documenting rural Southern life in the United States for the Farm Security Administration (the woman in Lange's photograph faces left, while Catlett's linocut image, drawn following Lange and reversed in the printing process, faces right), *Survivor* recalls the TGP's use of well-known photographic images as sources. Yet, while the woman in Lange's photograph is seen against the background of the field in which she toils, Catlett's minimally rendered background only suggests topography in its abstract linear pattern. Outlined in white, the woman becomes the unmistakable focus of the image. As in her earlier linocuts, Catlett utilized various nicks, gouges, and incised lines to delineate her subject's physical presence, but in contrast to her work at the TGP, this image is somewhat more spare, reminiscent of Kollwitz's later woodcuts.

Throughout her career as a printmaker, Catlett has returned to subjects and themes that matter to her, particularly the strength and resilience of ordinary working women and heroic African American foremothers. Her 1975 *Harriet* (plate 22) is a powerful restatement of her admiration for the woman she had portrayed twice before: in her *Negro Woman* series and again as part of a collective project she organized in 1953-54 at the Taller de Gráfica Popular, now known as *Against Discrimination in the U.S.*[28] The powerfully thrusting gesture of this Harriet, barely contained by the print's edges, links her to Catlett's earlier "In Harriet Tubman I helped hundreds to freedom" (plate 8) from *The Negro Woman*, as does the mass of people following her command. But the facial expression, gesture, and stance of

this heroine are more fiercely energetic, the entire linocut infused with vigorous dynamism by the forceful linear hatching through which Catlett acknowledges and honors the fundamental importance of her years of experience at the Taller de Gráfica Popular, an experience that continues to inflect her artistic vision. Harriet is at once a statement of her deeply rooted lifelong identification with her African American ancestry and heritage, and her politics of justice and liberation for all people.

Throughout her life, Catlett has moved between cultures, participating in communities that transcend national boundaries in their concerns and convictions. In these communities of politically engaged artists—whether in Chicago, Harlem, or Mexico City— Catlett developed and refined the visual language through which she represents and speaks to those whose histories and experiences have not been represented in art. Her United States citizenship was restored in 2002, and she is now a citizen of both the United States and Mexico. Still inextricably interwoven, her social and aesthetic visions remain grounded in what she learned about people's art through the lively collaborative ethos of the TGP, the community that sustained her for decades in Mexico. In her words,

Art can't be the exclusive domain of the elect. It has to belong to everyone. Otherwise it will continue to divide the privileged from

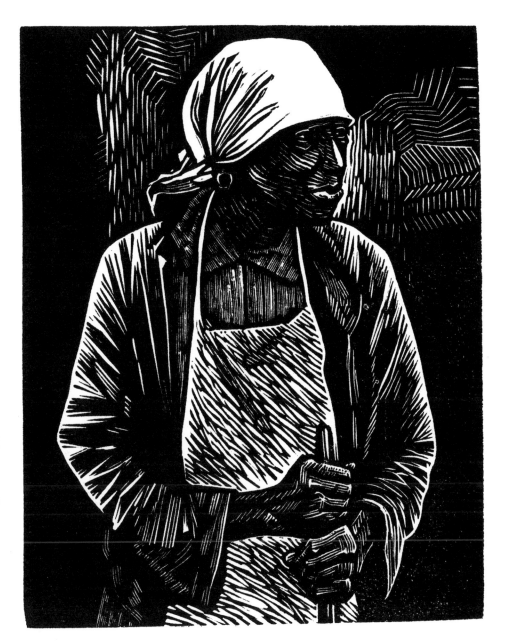

PLATE 21

Survivor, 1983;
linoleum cut, 30.5 x 25.5 cm.
Collection of Judy and Patrick Diamond.

the underprivileged, Blacks from Chicanos, and both from rural, ghetto, and middle-class whites. Artists should work to the end that love, peace, justice, and equal opportunity prevail all over the world; to the end that all people take joy in full participation in the rich material, intellectual, and spiritual resources of this world's lands, peoples, and goods.[29]

Now celebrated as a foremother herself by younger generations of African American artists, at age ninety Elizabeth Catlett continues to experiment with various printmaking processes. She maintains her conviction that art can be a source of pride, raise awareness of social issues, and offer a vision of a more just world, as she voices — through her prints — both her commitment to art made in the image of the people, and her concern for the past and future of all humanity.

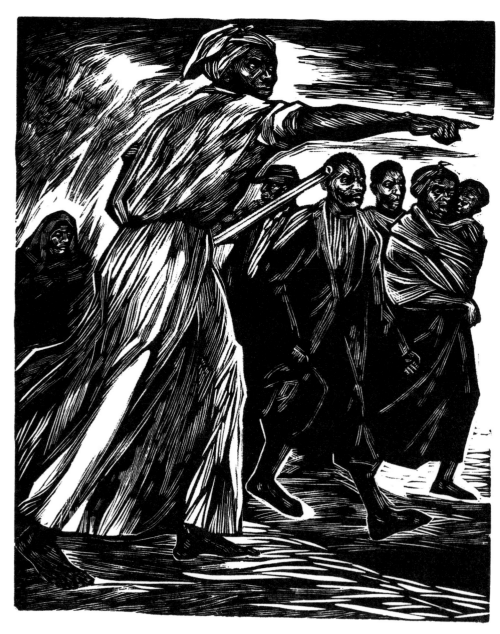

PLATE 22

Harriet, 1975;
linoleum cut, 32 x 25.5 cm.
Collection of Isobel Neal.

NOTES

1. Much of the research for this essay was done initially for my Ph.D. dissertation, "'My Art Speaks for Both My Peoples': Elizabeth Catlett in Mexico" (University of Wisconsin, 1995), and for my book, which contains a fuller treatment of Catlett's life and art; see Melanie Anne Herzog, *Elizabeth Catlett: An American Artist in Mexico* (University of Washington Press, 2000). See also Samella Lewis, *The Art of Elizabeth Catlett* (Hancraft Studios, 1984); and Elton Fax, "Elizabeth Catlett," in *Seventeen Black Artists* (Dodd and Mead, 1971). Catlett discusses her early years in audiotaped interviews with Glory Van Scott (Dec. 8, 1981), Clifton Johnson (Jan. 5 and 7, 1984), Camille Billops (Oct. 1, 1989), and Melanie Herzog (June 14 and 15, July 6, and Dec. 1, 1991, and Jan. 3 and 4, 1993) and in handwritten manuscripts for lectures and slide presentations; audiotapes of Clifton Johnson interviews and manuscripts in Elizabeth Catlett Papers, Amistad Research Center, Tulane University, New Orleans, Louisiana. Partial transcriptions of the Van Scott and Billops interviews can be found in "Elizabeth Catlett: Sculptor, Printmaker," in *Artist and Influence*, vol. 10, edited by James V. Hatch and Leo Hamalian (Hatch-Billops Collection, 1991), pp. 1-27. I thank Elizabeth Catlett for making available to me the audiotapes of these interviews.

2. Interview with Melanie Herzog, June 14, 1991; interview with Glory Van Scott (note 1), p. 2. On the Howard University art department, the first established at a historically black university, see Keith Morrison, *Art in Washington and Its Afro-American Presence: 1940-1970* (Washington Project for the Arts, 1985).

3. Lewis (note 1), p. 15. See also Elizabeth Catlett, "Responding to Cultural Hunger," in *Reimaging America: The Arts of Social Change*, edited by Mark O'Brien and Craig Little (New Society Publishers, 1990), p. 244.

4. See Alain Locke, "Chicago's New Southside Art Center," *Magazine of Art* 34, no. 7 (Aug.-Sept. 1941), pp. 370-74; also Commission on Chicago Landmarks, *South Side Community Art Center, 3831 South Michigan Avenue* (The Commission on Chicago Landmarks, 1993). For Burroughs's perspective on the South Side Community Art Center, see "Margaret Taylor Burroughs Interviews, 1988, November 11 and December 5," interview with Anna M. Tyler (Archives of American Art, Smithsonian Institution, 1988); Margaret Goss Burroughs, "Chicago's South Side Community Art Center: A Personal Recollection," in *Art in Action: American Art Centers and the New Deal*, edited by John Franklin White (Scarecrow Press, 1987), pp. 131-44; and Margaret T. Burroughs, "Saga of Chicago's South Side Community Art Center (1938-1943)" and "Remarks: South Side Art Center, 40th Anniversary, June 17, 1981," in *The South Side Community Art Center 50th Anniversary, 1941-1991* (South Side Community Art Center, 1991).

5. On Chicago's literary renaissance, see Robert Bone, "Richard Wright and the Chicago Renaissance," *Callaloo* 28 (Summer 1986), pp. 446-68; also Craig Werner, "Literary History: Early Twentieth Century," in *The Oxford Companion to African American Literature*, edited by William L. Andrews (Oxford University Press, 1997), pp. 453-56. On Chicago's black visual artists, see Daniel Schulman, "'White City' and 'Black Metropolis': African American Painters in Chicago, 1893-1945," in *Chicago Modern, 1893-1945: Pursuit of the New*, edited by Elizabeth Kennedy (Terra Museum of American Art, 2004), pp. 39-51; Bernard Goss, "Ten Negro Artists on Chicago's South Side," *Midwest: A Review* 1, no. 2 (Dec. 1936), pp. 17-19; and Willard F. Motley, "Negro Art in Chicago," *Opportunity* 18, no. 1 (Jan. 1940), pp. 19-22 and 28-31.

6. Little documentation is available on the history and activities of the Carver School. On Catlett's work at the school, see Herzog, *Elizabeth Catlett* (note 1), pp. 36-40; Lewis (note 1), pp. 18-20; Fax (note 1), pp. 22-24; and various interviews.

7. From a lecture by Catlett at Wooster College, Ohio, Nov. 10, 1981; handwritten manuscript in Elizabeth Catlett Papers, Amistad Research Center; quoted in Thalia Gouma-Peterson, "Elizabeth Catlett: The Power of Human Feeling and of Art," *Woman's Art Journal* 4, no. 1 (Spring-Summer 1983), p. 50; see also Catlett (note 3), pp. 244-45.

8. See, for example, Alain Locke, "The Legacy of the Ancestral Arts," in *The New Negro: An Interpretation*, edited by Alain Locke (1925; rpt. Arno Press, 1968), pp. 254-67.

9. See Lizzetta LeFalle-Collins and Shifra M. Goldman, *In the Spirit of Resistance: African-American Modernists and the Mexican Muralist School / En el espíritu de la resistencia: Los modernistas africanoamericanos y la Escuela Muralista Mexicana* (The American Federation of Arts, 1996), particularly Lizzetta LeFalle-Collins, "African-American Modernists and the Mexican Muralist School/Los modernistas africanoamericanos y la Escuela Muralista Mexicana," pp. 27-67. See also Alison Cameron, "Buenos Vecinos: African-American Printmaking and the Taller de Gráfica Popular," *Print Quarterly* 16, no. 4 (Dec. 1999), pp. 353-67.

10. By the mid-1950s, hundreds of groups were named on the Attorney General's list; see Ellen Schrecker, *The Age of McCarthyism: A Brief History with Documents* (Bedford Books, St. Martin's Press, 1994), pp. 151-53. HUAC drew broad public attention beginning in 1947 with its investigations of presumed Communist sympathizers in the entertainment industry; see Allan M. Winkler, "Hollywood and HUAC," in *The Cold War: A History in Documents* (Oxford University Press, 2000), pp. 46-50. On anti-Communism in the United States, see Howard Zinn, *A People's History of the United States, 1492-Present* (HarperCollins, 2003), pp. 425-37; also Winkler, particularly his chapter "The Anti-Communist Crusade," pp. 45-69.

11. On the Taller de Gráfica Popular, see Helga Prignitz, *TGP: Ein Grafiker-Kollektiv in Mexico von 1937-1977* (Verlag-Seitz, 1981), also published in Spanish as *El Taller de Gráfica Popular en México 1937-1977*, trans. by Elizabeth Siefer (Instituto Nacional de Bellas Artes, 1992). See also *TGP Mexico: El Taller de Gráfica Popular: Doce años de obra artística colectiva/The Workshop for Popular Graphic Art: A Record of Twelve Years of Collective Work*, edited by Hannes Meyer (La Estampa Mexicana, 1949), and Dawn Ades, "The Taller de Gráfica Popular," in *Art in Latin America: The Modern Era, 1820-1980* (Yale University Press, 1989), pp. 181-93.

12. *El Libro Negro del Terror Nazi en Europa / The Black Book of Nazi Terror in Europe* (Editorial El Libro Libre, 1943), p. 320; for a list of contributors to this volume, see Prignitz, *El Taller de Gráfica Popular* (note 11), pp. 397-98; see also *TGP Mexico* (note 11), p. 8.

13. See David Alfaro Siqueiros, *No hay mas ruta que nuestra*, talleres gráficos núm. 1 (Secretaría de Educación Pública, 1945); also Elliot Clay, "Siqueiros: Artist in Arms," *Masses and Mainstream* 4, no. 4 (April 1951), pp. 60-73.

14. *Estampas de la Revolución Mexicana*, 85 grabados de los artistas del Taller de Gráfica Popular (La Estampa Mexicana, 1947). This portfolio consists of original prints by the sixteen members of the Taller de Gráfica Popular. A numbered edition of 500 was printed for international distribution; an additional fifty numbered with roman numerals I through L were not for sale.

15. See *Paintings, Sculpture, and Prints of The Negro Woman by Elizabeth Catlett* (Barnett-Aden Gallery, 1947), the catalogue for Catlett's initial exhibition of her Rosenwald project that was published as a single folded sheet. Later exhibitions and prints from this series titled by Catlett in subsequent decades display some variations, notably the use of "Black" instead of "Negro." For a fuller discussion of this series, see Herzog, *Elizabeth Catlett* (note 1), pp. 56-66.

16. Richard J. Powell, "Face to Face: Elizabeth Catlett's Graphic Work," in *Elizabeth Catlett: Works on Paper, 1944-1992*, edited by Jeanne Zeidler (Hampton University Museum, 1993), p. 52.

17. Catlett discussed her response to segregated transportation in New Orleans in an interview with Clifton Johnson, Jan. 5, 1984. See also Herzog, *Elizabeth Catlett* (note 1), pp. 24-25.

18. Stuart Hall, "Cultural Identity and Diaspora," in *Identity, Community, Culture, Difference*, edited by Jonathan Rutherford (Lawrence and Wishart, 1990), p. 222.

19. Stuart Hall, "Old and New Identities, Old and New Ethnicities," in *Culture, Globalization, and the World-System: Contemporary Conditions for the Representation of Identity*, edited by Anthony D. King (State University of New York at Binghamtom, 1991), p. 49.

20. Interview with Melanie Herzog, June 15, 1991.

21. Powell (note 16), p. 53. On Catlett in Mexico, see also Melanie Herzog, "Elizabeth Catlett in Mexico: Identity and Cross-Cultural Intersections in the Production of Artistic Meaning," *International Review of African American Art* 11, no. 3 (Summer 1994), pp. 18-25 and 55-60.

22. *La presa* was one of eight TGP prints made for a conference on the Mexican government's Hydraulic Resources Program (El programa de recursos hidráulicos del gobierno de México), and it was included in an exhibition sponsored by the Frente Nacional de Artes Plásticas and the Secretaría de Recursos Hidráulicos in 1952.

23. *Sharecropper* was published in 1957 as *Cosechadora de algodón* in a special edition of the journal *Artes de México* devoted entirely to the history and work of the Taller de Gráfica Popular in commemoration of the workshop's twentieth anniversary. The issue also included a transcript compiled by Raquel Tibol from conversations with members of the workshop; see *Artes de México* 3, no. 18 (July-Aug. 1957). See also Kenneth G. Rodgers, "Elizabeth Catlett," catalogue entry in Richard J. Powell and Jock Reynolds, *To Conserve a Legacy: American Art from Historically Black Colleges and Universities* (Phillips Academy, Addison Gallery of American Art; and Studio Museum in Harlem, 1999), pp. 181-83; and Melanie Herzog, "Elizabeth Catlett," catalogue entry in Elizabeth Seaton, et al., *Paths to the Press: Printmaking and American Women Artists, 1910-1960* (Kansas State University, Marianna Kistler Beach Museum of Art, forthcoming). In accord with the TGP's philosophy and practice, early prints of *Sharecropper* were not editioned. I am grateful to Ellen Sragow for kindly sharing information with me on the history of Catlett's *Sharecropper*.

24. Elizabeth Catlett, interview with Clifton Johnson, Jan. 7, 1984. See also Karl M. Schmitt, *Communism in Mexico: A Study in Political Frustration* (University of Texas Press, 1965), pp. 140-42; and Prignitz, *El Taller de Gráfica Popular* (note 11), p. 142. Prignitz cites conversations with various Taller artists who were denied entry to the United States during the 1950s and 1960s.

25. For Catlett's talk at the National Conference of Negro Artists, see Elizabeth Catlett, "The Negro People and American Art," *Freedomways* 1, no. 1 (Spring 1961), pp. 74-80; reprinted in part in Lewis (note 1), pp. 97-101. On her exhibition at the Studio Museum in Harlem, see *Elizabeth Catlett: Prints and Sculpture*, foreword by Elton Fax, commentary by Jeff Donaldson (Studio Museum in Harlem, 1971). In this catalogue her 1947 exhibition of *The Negro Woman* at the Barnett-Aden Gallery in Washington, D.C., is now titled *The Black Woman*.

26. On Catlett and the Black Arts Movement, see Mary Schmidt Campbell, "Part I: The Civil Rights Movement— An Awakening," and "Part II: A Turbulent Decade," in *Tradition and Conflict: Images of a Turbulent Decade, 1963-1973* (Studio Museum in Harlem, 1985). On Catlett's woman-centered perspective, see Freida High Tesfagiorgis, "Afrofemcentrism and Its Fruition in the Art of Elizabeth Catlett and Faith Ringgold (A View of Women by Women)," *Sage* 4, no. 1 (Spring 1987), pp. 25-32, reprinted in *The Expanding Discourse: Feminism and Art History*, edited by Norma Broude and Mary D. Garrard (Icon Editions, 1992), pp. 475-85.

27. Elizabeth Catlett, handwritten manuscript for lecture and slide presentation, New Orleans Museum of Art, Oct. 15, 1983, p. 2; in Elizabeth Catlett papers, Amistad Research Center.

28. See "Veinte años de vida del Taller de Gráfica Popular," *Artes de México* 18 (July-Aug. 1957), n. pag.; Prignitz, *El Taller de Gráfica Popular* (note 11), pp. 418-19; and Herzog, *Elizabeth Catlett* (note 1), pp. 101-04. Intended for publication in the newspaper *Freedom*, published by Paul Robeson from 1950 until 1955, the series was never published.

29. Quoted in Lewis (note 1), p. 26.

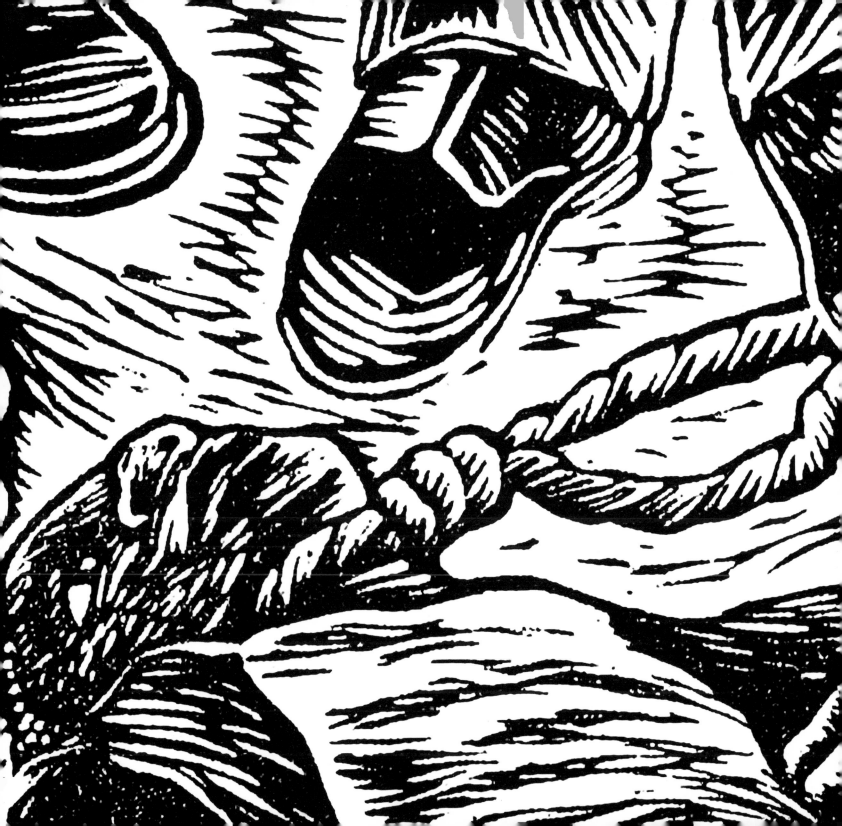

Printmaker and sculptor Elizabeth Catlett played an influential role in America's African American and Mexico's revolutionary art communities in the mid-twentieth century. She studied art at Howard University in Washington, D.C., and at the University of Iowa (where she briefly worked with Grant Wood), the School of the Art Institute of Chicago, and the Art Students League of New York, before moving to Mexico in 1947.

Focusing on Catlett's evocative series entitled *The Negro Woman* from 1946-47, this book reveals Catlett's commitment to social and political issues. All of the fifteen linoleum prints are beautifully reproduced and together they address the harsh reality of black women's labor; honor renowned historical heroines such as Sojourner Truth, Harriet Tubman, and Phillis Wheatley; and depict the fears, struggles, and achievements of ordinary African American women. Other notable works by Catlett are also included, and an absorbing essay by distinguished scholar Melanie Anne Herzog analyzes the artist's powerful work.

THE ART INSTITUTE OF CHICAGO
YALE UNIVERSITY PRESS